ideals® CHRISTMAS

*May the traditions and
spirit of Christmas
fill your home with
love and peace.*

NASHVILLE, TENNESSEE

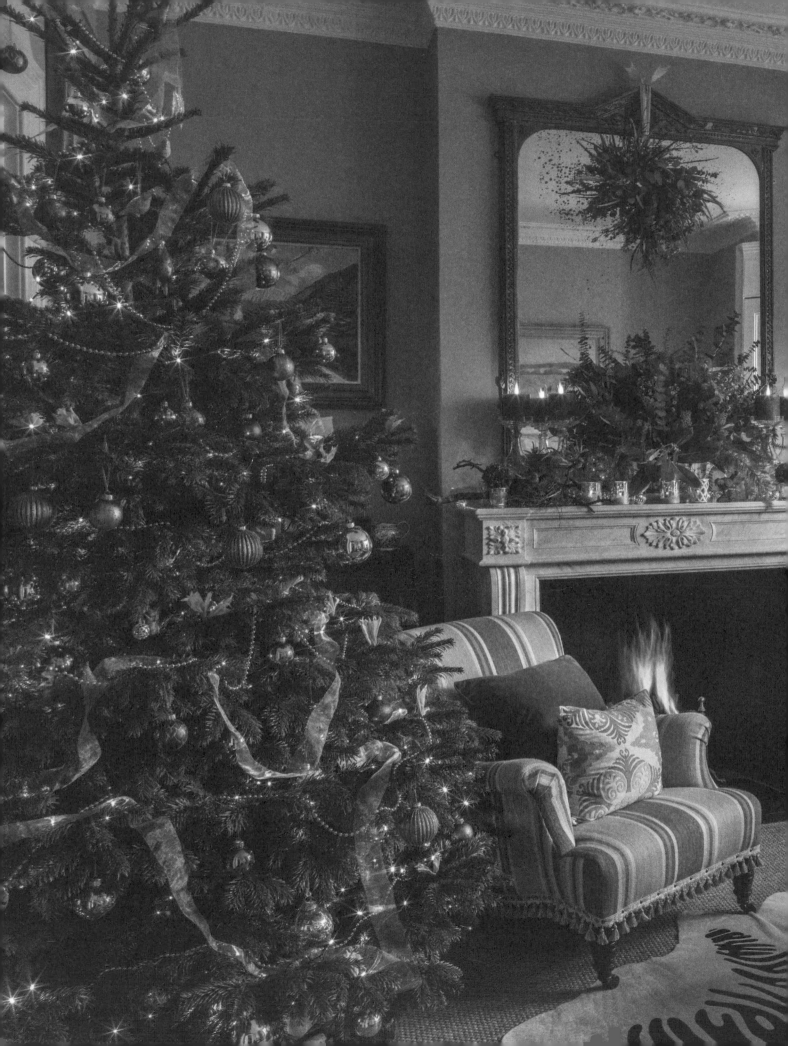

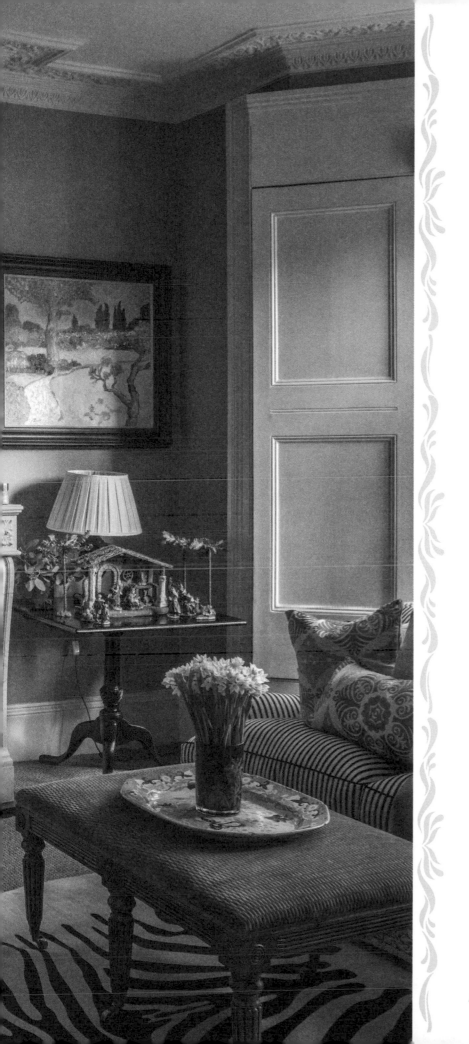

Christmas
Marchette Chute

My goodness, my goodness,
it's Christmas again.
The bells are all ringing.
I do not know when
I've been so excited.

The tree is all fixed;
the candles are lighted;
the pudding is mixed.
The wreath's on the door
and the carols are sung;
the presents are wrapped
and the holly is hung.

The turkey is sitting
all safe in its pan,
and I am behaving
as calm as I can.

A Catch by the Hearth
Author Unknown

Sing we all merrily;
Christmas is here,
the day that we love best
of days in the year.

Bring forth the holly,
the box, and the bay;
deck out our cottage
for glad Christmas Day.

Sing we all merrily;
draw round the fire,
sister and brother,
grandsire and sire.

Home at Christmastime

Kathy Jones

Christmas is the best time of year to be home. The holidays, though greeted by Mother Nature with chill winds and vistas turning white with snow, are full of special moments meant for sharing. A fire blazes hot in the stone fireplace and boughs of fresh-cut pine line the mantel, filling the entire house with the scent of the forest. A bit of mistletoe, tied with a bright red ribbon, dangles provocatively over the doorway. There are baskets filled with rich treats for friends and neighbors, and pretty dishes filled with sweets for the family.

Carols echo from every street corner, mulled cider stays warm by the fire, and chestnuts roast on the hearth. Snowflakes drift out of the silent night sky, the windows are artfully decorated by the lacy fingers of Jack Frost, and crystal icicles sparkle among the eaves of the house. A huge pine tree dominates the room, its limbs heavy with strings of popcorn and cranberries, glass ornaments, and shiny tinsel. At the very top of the tree, the little angel's porcelain eyes watch the activity of the season unfold below her, as they have done since my great-grandfather was a child. Presents, wrapped in an array of reds, blues, greens, and golds, are piled beneath the tree to await tomorrow morning, when the family will gather to rip and tear through the ribbon and tape to discover what St. Nicholas left them this year.

Woven from the fabric of these traditions is a rich tapestry of memories that makes Christmas and home inseparable for me.

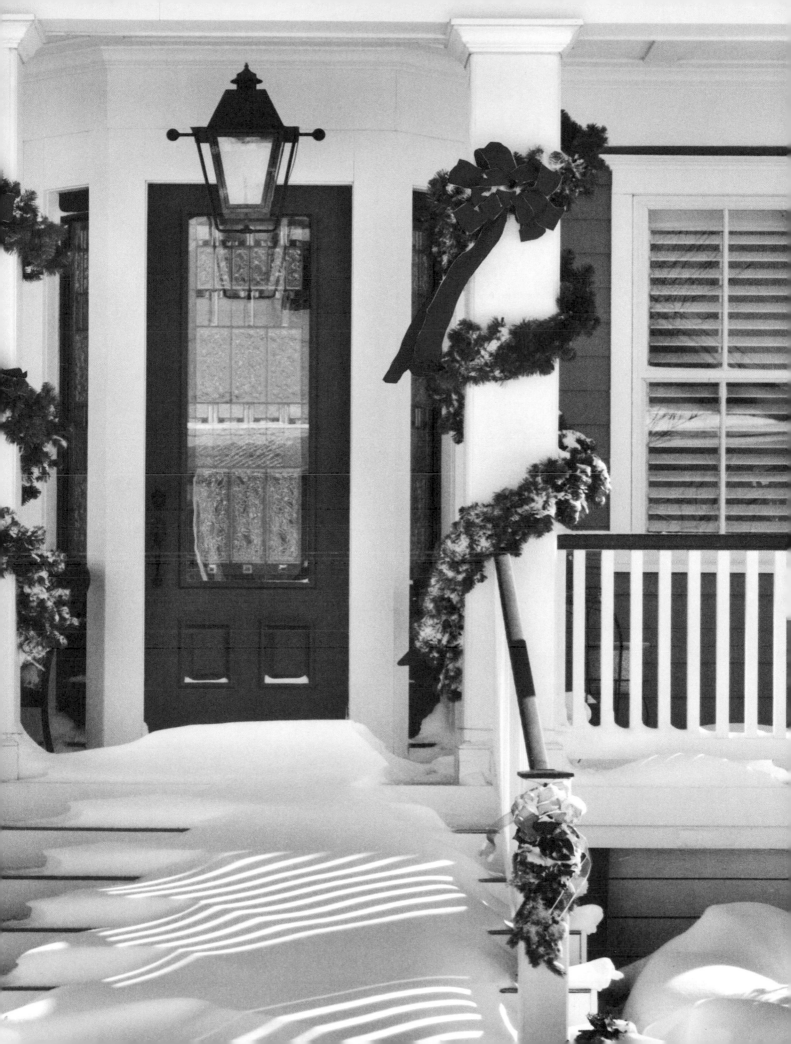

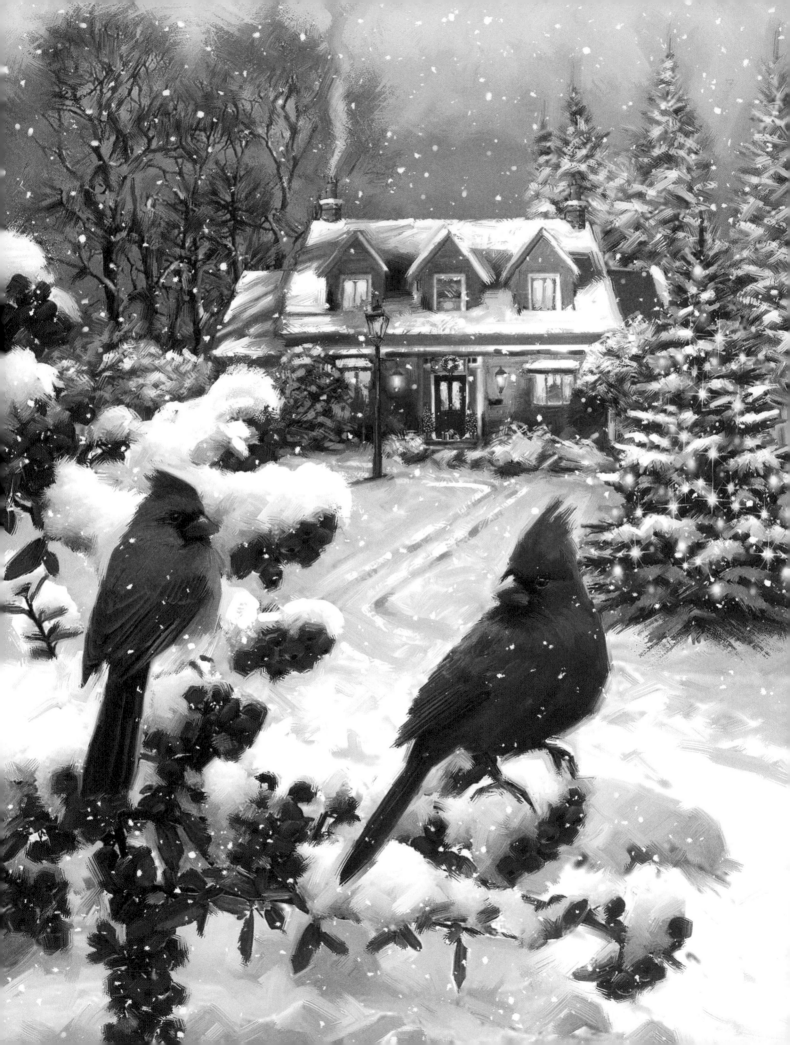

The Homey Road

Agnes Davenport Bond

There is a homey road
that leads to lighted windows
where the candles glow,
where wreaths of holly blend
with evergreen and mistletoe.

There is a homey road
that leads across the mountains
and the seven seas,

a homey road that leads
to open fires and Christmas trees.

There is a homey road
that ends at joyous meetings
and dear familiar sights,
where love and happiness
are linked with peaceful
 candle lights.

They'll Be Home for Christmas

Nelle Hardgrove

Jingle bells and tinsel
and trimmings tucked away
are coming from their
 wrappings
to grace the holiday.

Cookies in the making
and presents ten feet tall,

songs to sing and bells to ring
and Christmas cheer for all.

Dreams and hopes and wishes
will all be coming true.
But, best of all,
the ones you love
are coming home to you!

The Joy of Giving
John Greenleaf Whittier

Somehow, not only for Christmas,
but all the long year through,
the joy that you give to others,
is the joy that comes back to you.

And the more you spend in blessing
the poor and lonely and sad,
the more of your heart's possessing
returns to make you glad.

Christmas Gifts
Alberta Dredla

Of all the gifts
that Christmas brings,
the best are made of little things:

melody of carols all the year,
cheer to friends that you hold dear,
courage to someone else to start
some task for which he hasn't heart,

thoughts for those with less than you,
faith for a future not in view,
fun and laughter to go everywhere,
kindness to show how much you care,
strength to begin all over again,
and love to seek the best in every man.

While other seasons come and go
and another year hurries past,
let's give again the little things . . .
they are the gifts that last.

Home Scene
Sandi Keaton-Wilson

The night sky is alight with stars,
and moon glow shines on snow.
Little ones are tucked in bed,
and little do they know

that Mom and Dad are scurrying
around like country mice,
filling stockings with sweet fruit
and wrapping gifts so nice!

The fireplace lights up the room;
bright bulbs hang on the tree;
and Mom and Dad delight in sights
their precious ones will see.

There is no night quite like this one,
when hearts most surely believe
that the best, most loving part
 of Christmas
is to give more than receive.

Through My Window

A Hand-Crafted Christmas

Pamela Kennedy

With winter winds whirling and more time at home, last Christmas season provided the perfect opportunity for diving into long-ignored boxes stuffed with craft supplies and fabric scraps. Instead of crowds in shopping malls, I determined to confront the abundance of resources I had saved "for later." Later had arrived!

Scouring the internet, I discovered a bounty of creative gift ideas . . . some definitely better than others. I could think of no one on my list who would cherish a doormat woven from recycled plastic bags or a colorful vest created from discarded neckties. I also rejected quilts, knitted items, and anything crocheted due to my lack of skill in all of these departments. But I had recently taken up the art of needle felting, thanks to a gift of a starter kit from my daughter-in-law. And I had a sewing machine, lots of fabric, several pairs of socks purchased for a long-forgotten project, access to a forest, and an active imagination.

As often happens around my house, I also enlisted my husband and his vast array of tools and woodworking skills. Although not quite so active in the imagination department, he humors me on a regular basis.

"What in the world is a fairy house?" he wondered, when I suggested he make one for our granddaughter.

I described a three-story open-sided structure with each floor supported by small sections of tree branches. "You can make the floors from those oak cabinet doors you salvaged, and you can make a little table and chairs from cross sections of tree branches!" I explained, pointing to the woods across the street. "I'm making a little felt hammock for them to sleep in."

"Who is sleeping in there?" he queried.

"The gnomes and fairies. I'm crafting them from fabric-covered wooden pegs with little embroidered hats!"

I showed him a photo I had found online. "Look, this would cost $500! Think of how much we're saving!"

He headed for his shop while I moved on to researching ways to utilize spare socks. Before long, we were humming along like a couple of elves in Santa's workshop. I whipped up a couple of sock dolls for baby Helen and sock monkeys for the older kids. Lesson learned: knee socks yield monkeys with legs almost as long as a young grandchild! Following an online tutorial, I needle-felted little wool gnomes with pointy hats and wild beards and placed them in a row on the windowsill.

"Looks like a Scandinavian police lineup," observed my husband at lunchtime.

"How's that fairy house coming along?" I responded.

I unearthed fabric originally intended for outdoor tablecloths and repurposed it as butcher aprons for all the male members of the family.

When I discovered a simple pattern for making absolutely darling snowmen using socks filled with rice, I went crazy.

"Why do we need two ten-pound bags of rice for just two of us?" my incredulous husband asked, hauling my groceries into the kitchen. "I don't even like rice."

"Snowmen!" I replied cheerfully. "And are you finished with that fairy house yet? Because I just saw this amazing idea for making coasters out of slices of tree limbs."

For weeks we cut and sewed, stuffed and glued, sawed and sanded and varnished. One chilly after-noon I glanced out of the kitchen window and waved as I saw my husband wrestling an alder limb into submission. He gave me a thumbs-up.

I hummed a Christmas carol as I packed the last box to mail, reflecting on the joys of a hand-crafted Christmas. There was a knock on the door. I opened it to find my grinning spouse standing on the porch holding the completed three-story fairy house. The little hammock swung back and forth.

"Check this out," he said pointing to the front of a small branch supporting the second floor. On it was a tiny square of wood, topped by two slivers of tree bark. I squinted to get a closer look.

"It's a birdhouse!" he exclaimed.

I raised an eyebrow. "For the fairies?"

He chuckled, his eyes twinkling. "You're not the only one with an imagination, you know."

Curiosity

Georgia B. Adams

Pretty package on the shelf,
quite hid away from sight!
I spied it sitting oh-so-still,
all wrapped and ribboned bright!

And then, just once, I picked it up
(no one was there to see!).
It rattled just a wee, wee bit—
this Christmas gift for me!

Was it a toy, or pretty doll?
A painting set, or skates?
How long till Christmastime was here—
oh, I could hardly wait!

I put it back so carefully
and hid it out of sight—
pretty package on the shelf,
all wrapped and ribboned bright.

Secrets

E. Kathryn Fowler

If you see a package
nicely wrapped and tied,
don't ask too many questions,
'cause a secret is inside.

Do Not Open
Until Christmas

James S. Tippett

I shake-shake,
shake-shake,
shake the package well.

But what there is
inside of it,
shaking will not tell.

Bits & Pieces

And up at the top was fixed a large star of gold tinsel; it was magnificent beyond words!

—*Hans Christian Andersen*

Christmas is a time for children. Children in stores, watching electric trains, gazing at beautiful bride dolls; children singing age-old Christmas carols; children playing in the snow; children whispering wonderful secrets to Santa Claus.

—*Linda Ann Hughes*

Every gift which is given, even though it be small, is in reality great, if it is given with affection.

—*Pindar*

I often object to the notion that "Christmas is for the children," because Christmas is so profoundly for the rest of us too.
—Derek Maul

Christmas now surrounds us;
happiness is everywhere;
our hands are busy with many tasks
as carols fill the air.
—Shirley Sallay

The smells of Christmas are the smells of childhood.
—Richard Paul Evans

Let every pudding burst with plums, and every tree
bear dolls and drums, in the week when Christmas comes.
—Eleanor Farjeon

Christmas is the season of joy, of holiday greetings
exchanged, of gift-giving, and of families united.
—Norman Vincent Peale

Love is what's in the room
with you at Christmas if you stop
opening presents and listen.
—Author Unknown

My Christmas Stocking

LaVerne P. Larson

Each Christmas Eve when I was small
I'd hang my stocking there,
right above the chimney place
with special, loving care.

My heart was filled with hopes and dreams
of things it would contain,
goodies and gifts of every sort
straight from Santa's lane.

Hang Up the Baby's Stocking

Emily Huntington Miller

Hang up the baby's stocking:
be sure you don't forget;
the dear little dimpled darling,
she ne'er saw Christmas yet;
but I've told her all about it,
and she opened her big blue eyes,
and I'm sure she understood it—
she looked so funny and wise.
Dear! What a tiny stocking!
It doesn't take much to hold
such little pink toes as baby's
away from the frost and cold.
But then for the baby's Christmas
it will never do at all;
why, Santa wouldn't be looking
for anything half so small.

I know what will do for the baby.
I've thought of the very best plan:
I'll borrow a stocking of grandma,
the longest that ever I can;
and you'll hang it by mine, dear mother,
right here in the corner, so!
And write a letter to Santa,
and fasten it on to the toe.
Write, "This is the baby's stocking
that hangs in the corner here;
you never have seen her, Santa,
for she only came this year,
but she's just the blessedest baby!
And now, before you go,
just cram her stocking with goodies,
from the top clean down to the toe."

A Just-Us Christmas

Anne Kennedy Brady

This one!" My four-year-old son held aloft a hand-painted bread-dough ornament. It was a mouse dressed as an angel, barely two inches tall. I shook my head. "We have to wait for Christmas Eve to hang that one." He frowned and examined the others, finally settling on a mouse wearing a pink nightgown and cap. "I like the jammies one." We hung the "jammies" mouse on the green flannel tree and examined the twenty-three remaining hooks. My son bounced back to the box containing the other mice. "I'm excited to hang up the angel one," he observed. I smiled. "That's my favorite too."

Last year, for the first time since moving to Chicago nine years ago, we couldn't spend Christmas with our extended family in the Pacific Northwest. It felt odd. I missed my parents, in-laws, and brothers. I missed watching the cousins play together. But maybe there would be a positive side to our downsized, at-home Christmas. A simpler celebration with only the four of us might just hold its own special joys.

I got my first spark of that joy helping my son choose mouse ornaments. The Christmas countdown tree was a mainstay of my childhood Christmases. Each one of the twenty-four tiny mice is painted to represent a different holiday activity, and I remember agonizing over which one to choose to best represent that day's activities. Would the singing mouse or the ballet mouse

more clearly communicate that I acted in the church Christmas play that morning? My son is finally old enough and (barely) patient enough to understand counting down the days one at a time. As we would be home for the entire Christmas season this year, I was excited to complete the tree together for the first time in my own home.

Another upside to staying home for Christmas was the opportunity to control holiday baking decisions. I decided to bake cinnamon rolls for Christmas breakfast— something I'd always wanted to do. But the time investment for this breakfast dish worried me. Then I spied some store-bought refrigerated pie dough hanging around in the back of my fridge. I did some research. Could one make cinnamon rolls with pie dough?

Apparently not! But one can make cinnamon-roll cookies that will tide one over quite nicely until Christmas morning, thank you very much. I combined my favorite parts of a few online recipes and whipped up these goodies four separate times during the month of December—and successfully hid most of them from my children. Then I organized a cookie recipe exchange with my book club, mainly to show off my discovery. And while I did eventually gird my loins and make real live cinnamon rolls for the big day, I suspect the sweet, spicy (and incredibly easy) cookies will make an annual appearance of their own from now on.

I expected some melancholy as Christmas Eve approached. But, surprisingly, it brought some of my favorite new memories. True, we couldn't attend Christmas Eve service. But we did drive through the local arboretum's gorgeous light show, singing along to Christmas carols and marveling at the glory of nature. We didn't have a big family dinner. But after the kids were in bed, my husband and I shared Indian takeout—a callback to our first Christmas Eve together when my husband took me to a favorite restaurant, and we spent hours talking over tikka masala. Christmas morning, breakfast wasn't exactly on time (as it would have been at Mom's house), and there were no cousin wrestling matches or grandparent hugs. But we enjoyed finding our own pace. We snacked until the rolls were ready. We stopped periodically to assemble toys and put our daughter down for her nap. We flipped through new books right away, tried on clothes, and took space when we needed it. Christmas wasn't the same. But it was still full of joy. And it was just ours.

This year we're looking forward to traveling back to Seattle. We'll cram everyone into airplane seats and do the whirlwind family and friends visits, and it will be wonderful. But I do hope we'll be able to carry forward a few of the things we learned this year. We'll make more time for each other. We'll find joy in unexpected places. And maybe I'll even share a few more cookies with my kids. Maybe.

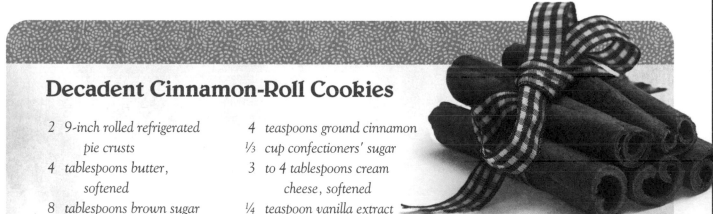

Decadent Cinnamon-Roll Cookies

2 9-inch rolled refrigerated pie crusts
4 tablespoons butter, softened
8 tablespoons brown sugar
4 teaspoons ground cinnamon
⅓ cup confectioners' sugar
3 to 4 tablespoons cream cheese, softened
¼ teaspoon vanilla extract

Allow pie crusts to stand at room temperature for 15 minutes. Unroll pie crusts on flat surface. Roll out each crust very thin to approximately 12 x 10 inches. Trim curved edges to create a rectangle. Spread 2 tablespoons butter evenly over each crust. Sprinkle brown sugar and cinnamon evenly over each crust. Roll up tightly lengthwise and shape into log. Press edges to seal. Wrap tightly in plastic wrap. Refrigerate at least 30 minutes.

Preheat oven to 375°F. Unwrap chilled logs. Use sharp knife to cut each log into ½-inch slices. Place slices flat, 1 inch apart on parchment-covered cookie sheets. Bake 8 to 12 minutes, or until edges are golden and filling begins to bubble. Cool 3 minutes; transfer to cooling rack to cool completely.

In small bowl, combine powdered sugar, 3 tablespoons cream cheese, and vanilla and stir until smooth. Add remaining cream cheese if needed to reach desired consistency. Spread or drizzle frosting onto cookies. Makes 48 cookies.

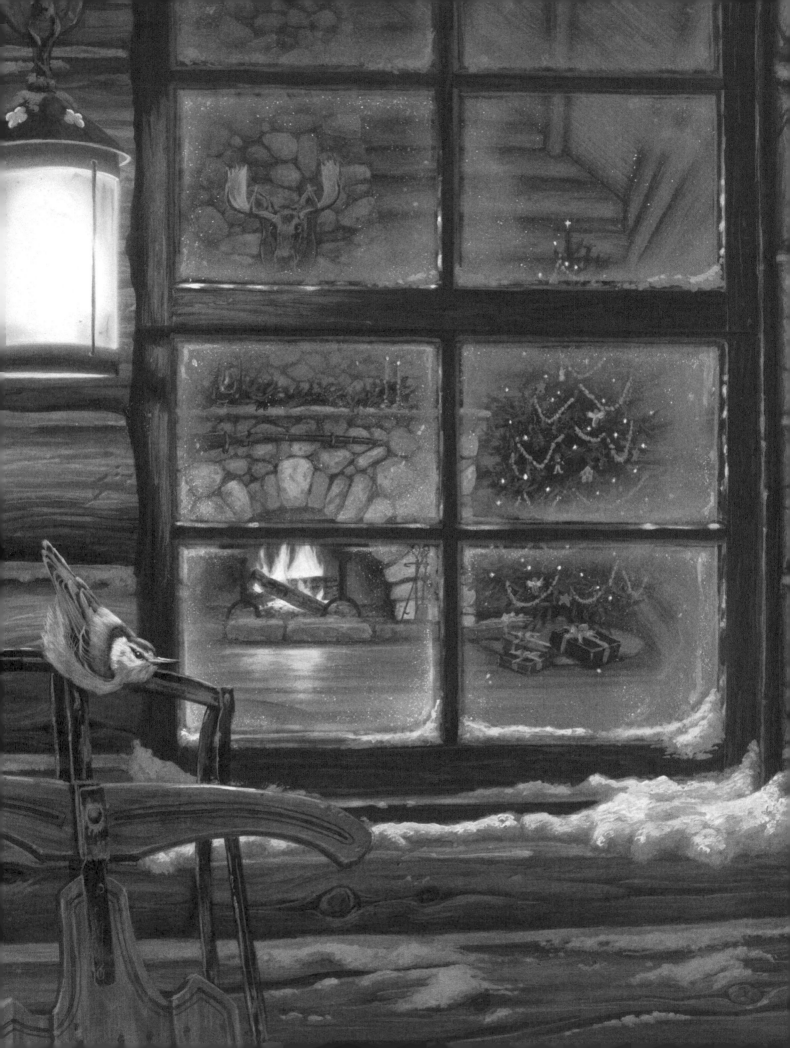

Merry Christmas
Louisa May Alcott

In the rush of early morning,
when the red burns through the gray,
and the wintry world lies waiting
for the glory of the day,
then we hear a fitful rustling
just without upon the stair,
see two small white phantoms coming,
catch the gleam of sunny hair.

Are they Christmas fairies stealing
rows of little socks to fill?
Are they angels floating hither
with their message of good will?
What sweet spell are these
 elves weaving,
as like larks they chirp and sing?
Are these palms of peace from heaven
that these lovely spirits bring?

Rosy feet upon the threshold,
eager faces peeping through,
with the first red ray of sunshine,
chanting cherubs come in view:
mistletoe and gleaming holly,
symbols of a blessed day,
in their chubby hands they carry,
streaming all along the way.

Well we know them, never weary
of this innocent surprise;
waiting, watching, listening always
with full hearts and tender eyes,
while our little household angels,
white and golden in the sun,
greet us with the sweet old welcome—
"Merry Christmas, everyone!"

The Puppy Who Came for Christmas

Sandra J. Payne

Who could resist that sweet Samoyed face? Definitely not us.

Our new puppy, Yukon, landed in our laps as an early Christmas present. He was a gift from family friends who knew how much I had loved playing with their Samoyed, Parga, during my childhood in Fairbanks, Alaska. When they called to see if we would like one of Parga's grandpuppies, of course we jumped at the chance to expand our two-cat household. At the time, we were newly married and living on Vance Air Force Base in Enid, Oklahoma. A puppy during the holidays seemed like an excellent idea.

As soon as he arrived, we were in love. Yukon's bright eyes always shone with a hint of mischief. His tongue generally lolled from one side of his fuzzy white face. He could get away with pretty much anything just by virtue of his "Sammy smile"—a famous trait of these wonderful, family friendly dogs.

He made himself right at home too. He liked digging holes in the backyard (especially after a rain), going for walks, barking up a storm, and chewing random items and pieces of paper. With Christmas near, he frequently risked being added to the Naughty List.

With the daily puppy hubbub, decorating the house for Christmas was a welcome diversion. Early one Saturday morning, my husband and I set out for our neighborhood tree lot.

A few hours later, we lugged a beautiful fir into the house, and Yukon seemed very impressed.

We worked diligently to let him know that, despite appearances, this indoor tree was not to be treated like an outdoor tree. This rule seemed to confuse him at first, but he figured it out.

We spent a happy afternoon trimming the tree, making sure to puppy-proof lower branches. There weren't too many presents yet, but luckily, a delivery from my parents had arrived a few days beforehand. It was a beautifully wrapped, bone-shaped gift addressed to Yukon. We tucked it under the tree.

Days went by with nary an incident. The cats enjoyed sleeping under the fir boughs, giving company to the lone present, and Yukon bounded around the house keeping us on our toes, adding a joyful energy to the Christmas season.

One night, we attended a party and came home later than normal. Yukon greeted us at the door with his usual enthusiasm. But this time, he had something in his mouth.

"Where did he get a toy bone?" I asked my husband, who looked as confused as I was.

Yukon radiated the innocence of a lamb.

But we knew the truth. We raced into the living room. Sure enough, the Christmas tree was missing its bone-shaped present, and the evidence that a gift had been vigorously unwrapped was everywhere in the form of wrapping-paper confetti.

Yukon made the Naughty List after all, but gave us the gift of laughter that Christmas, and for many years to come.

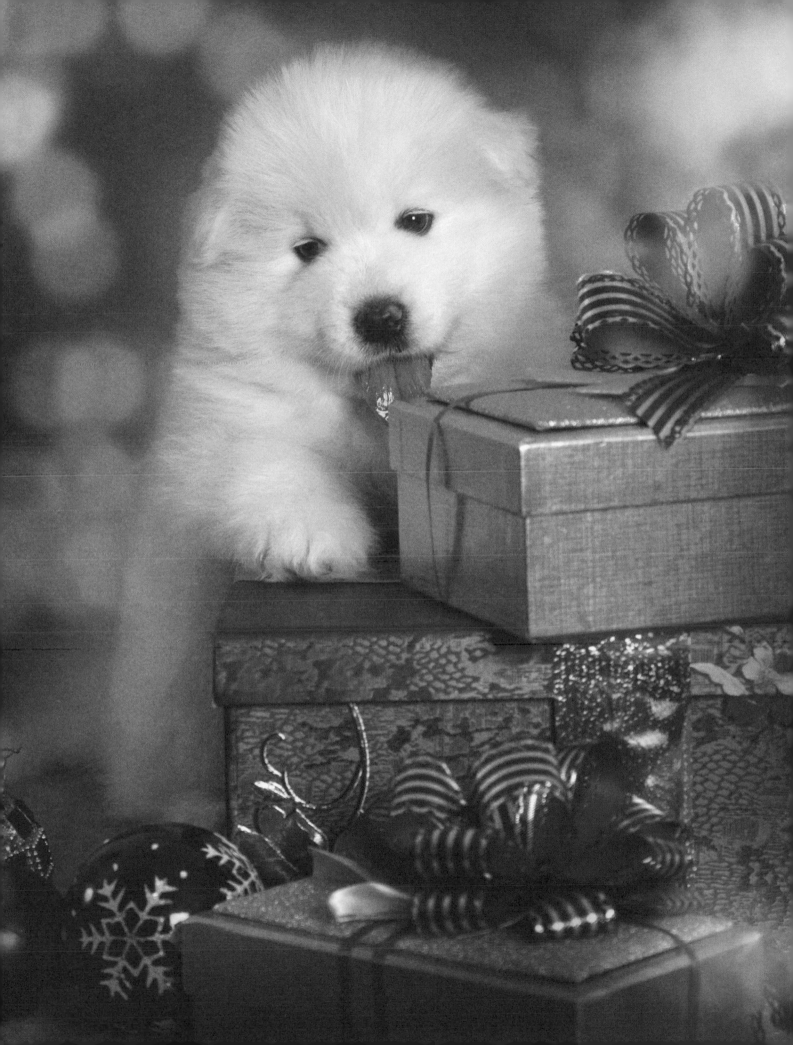

Trimming the Christmas Tree

Virginia Blanck Moore

It's time to trim the
 Christmas tree
we brought in from the cold.
Let's open up the boxes here
and see just what they hold.

There are baubles shining
 bright as stars,
all gold and red and green,
and silver tinsel by the yard,
the like you've never seen.

And in another box we find
the lights, and on they go.
And when they're
 plugged in finally,
how wonderfully they glow!

And here's the angel
 for the top,
so gold and white and bright,
and when the decorating's done,
how beautiful the sight.

And then we say
 (we always do),
each lassie and each lad,
forgetting all the
 years gone by,
"It's the best we've ever had!"

Round and Round

Dorothy Brown Thompson

Twist the tinsel,
flashing bright
round the tree
for our delight.

Twining, shining,
overhead,
wind the lights of
green and red.
Now join hands,
 and so will we
circle round the
Christmas tree,
singing still the
 holy word
that the watching
 shepherds heard:

"Peace on earth,
good will to men"—
Jesus' birthday
comes again!

Image © Africa Studio/Adobestock

Family Recipes

Bacon-Wrapped Sausages

1 14-ounce package beef cocktail sausages
1 pound sliced bacon, cut into thirds

¾ cup brown sugar, or to taste

Preheat oven to 325°F. Wrap each cocktail sausage with a piece of bacon and secure with a toothpick. Place on a large baking sheet. Sprinkle generously with brown sugar. Bake 40 minutes or until the sugar is bubbly. Serve warm in a slow cooker on the lowest setting. Makes 16 servings.

Holiday Salsa

2 14.5-ounce cans stewed tomatoes, drained
½ onion, finely diced
1 teaspoon minced garlic
½ lime, juiced

¼ teaspoon salt, or to taste
¼ cup canned sliced green chiles, or to taste
3 tablespoons chopped fresh cilantro
 Tortilla Chips

Place tomatoes, onion, garlic, lime juice, salt, green chiles, and cilantro in a blender or food processor. Blend on low to desired consistency. For best results, refrigerate at least 24 hours to allow full flavor to develop. Serve with tortilla chips. Makes 16 servings.

Cheesy Baked Artichoke Dip

1 14-ounce can artichoke hearts, drained
 and chopped
1 cup mayonnaise
1½ cups grated Parmesan cheese, divided
1½ cups shredded mozzarella cheese,
 divided
½ teaspoon garlic powder

Salt and black pepper to taste
Dash of hot sauce
Dash of Worcestershire sauce
1 tablespoon butter
½ cup minced yellow onion
French bread or tortilla chips

Preheat oven to 375°F. In a large bowl, mix together artichoke hearts, mayonnaise, 1 cup Parmesan, 1 cup mozzarella, garlic powder, salt, pepper, hot sauce, and Worcestershire sauce; set aside. In a small skillet over medium heat, melt the butter. Add the onion and sauté 8 to 10 minutes or until light golden brown.

Remove from heat and let cool slightly. Pour into artichoke mixture; mix well. Pour into baking or casserole dish. Top with remaining cheese. Bake 30 to 40 minutes or until golden brown and bubbly. Serve warm with toasted French bread or tortilla chips. Makes 32 servings.

Snowballs

1 cup unsalted butter, melted
2 cups all-purpose flour
1 cup finely ground pecans

3 tablespoons confectioners' sugar,
 plus more for rolling
1 teaspoon vanilla extract

Preheat oven to 325°F. In a large bowl, combine butter, flour, pecans, 3 tablespoons confectioners' sugar, and vanilla. Form into 1-inch balls and place on an ungreased baking sheet. Bake 12 to 15 minutes until lightly brown. Remove from oven and cool 3 to 5

minutes. While cookies are still hot, roll them in a shallow dish of confectioners' sugar (if cookies break up while rolling in sugar, cool another 3 to 5 minutes). Cool completely and roll each cookie in sugar again. Makes about 3 dozen cookies.

Baking
Christmas Cookies
Verna Sparks

I'm baking Christmas cookies,
and you should see me now,
with flour-draped cap and apron
and sugar on my brow.

It's a task that must be finished
before the twenty-fifth—
I wish someone could help me,
for I surely need a lift.

But everybody's busy
just the same as I—
they offer an apology
and hurry on with a sigh.

So, I stir and drop and bake them
in the oven golden brown,
then I box and bag and store them
before I settle down.

One thing is very certain,
when it's Christmas morning, though,
I'll have plenty of help with
 the cookies
since I'm finished with the dough.

And the joy I find in watching
my cookies disappear,
is a satisfying pleasure
Christmas brings to me each year.

Cookies are made
with butter and love.
—Norwegian Proverb

Image © Ruth Black/Adobestock

The Box from the Attic

Clara Brummert

Each year as I dust throughout the house and decorate for Christmas, I'm drawn back to that winter when I got home from college and helped Gram clear out her old holiday decorations. Dad went along to his parents' place to shovel the driveway and, by the time we arrived, Pap had been to the attic.

The living room was littered with boxes of decorations that needed to be sorted. Gram and I dug in and made stacks of things to discard and then decorated with the many things she wanted to keep. At the bottom of one carton, I came upon a tattered box and I was sure that I had found more junk.

But I gasped when I opened the flaps. Inside were three figurines, beautifully lifelike and vibrant with rich colors. From the box, the sweet infant Jesus lovingly reached up from His swaddling, and Mary and Joseph held kneeling poses that were steeped in humility. The fourth piece was a rough-hewn manger.

"Oh, my," Gram whispered. "I thought we lost those years ago when we moved."

The pieces were magnificent. As with an intriguing painting that has endless nuances, I couldn't stop staring at the beautiful figurine of baby Jesus. From one angle, the baby's arms stretched up in a pose that was an invitation to pick him up and pull him close to my heart. When I turned the figure around, his arms appeared to reach up and support a great weight.

I was still rotating the figure when Gram made her way through the boxes and settled down beside me. She tenderly touched the infant, as if meeting again with a long-lost friend.

Her voice was low when she said, "Your dad was born early, and it was a month before we could bring him home." She stared out the window before tacking on, "He was so tiny he looked lost in the crib."

Her eyes swept down and settled on the figurines. "That year, this nativity was a special comfort. We put it on the dresser in your dad's nursery, and it was a perfect reminder that the Holy Family watches over us."

We looked out to the driveway where Dad was clearing snow. His broad shoulders strained through his coat as he hefted the shovel.

Gram pulled her gaze back from Dad and meandered over to a box of tangled lights. We worked the afternoon away, stopping for a while to sip cocoa and read through the Christmas cards that arrived in the mail.

But always my eyes returned to the box, fearful that somehow the precious Christmas Child would be lost again. Once, I asked Gram where she'd like me to place the pieces. "I know the

perfect spot," she said vaguely and kept stuffing shabby tinsel into a trash bag.

We had just tied shut the last of the trash when Dad and Pap came in on a cold gust, ready for supper. Gram pulled a roast from the oven and mashed the potatoes while I arranged a plate of Christmas cookies for dessert.

"Well, look there!" Pap exclaimed when he saw the nativity. It still rested in its box on the floor. He surveyed the living room for a minute and then wondered aloud, "Where will it fit?" It seemed as if every inch was covered with the decorations we'd decided to keep.

Gram looked over at me and raised her eyebrows. "Would you like to have it? Perhaps someday you'll want to put Jesus' cradle beside your own baby's crib."

My eyes stung as I nodded.

Some years later, my husband and I welcomed our little girl into the world. Each time I laid her in the crib, I glanced at the nativity, then whispered a word of thanksgiving to the Christmas Child for giving to us such a wondrous gift.

Image © Comugnero Silvana/Adobestock

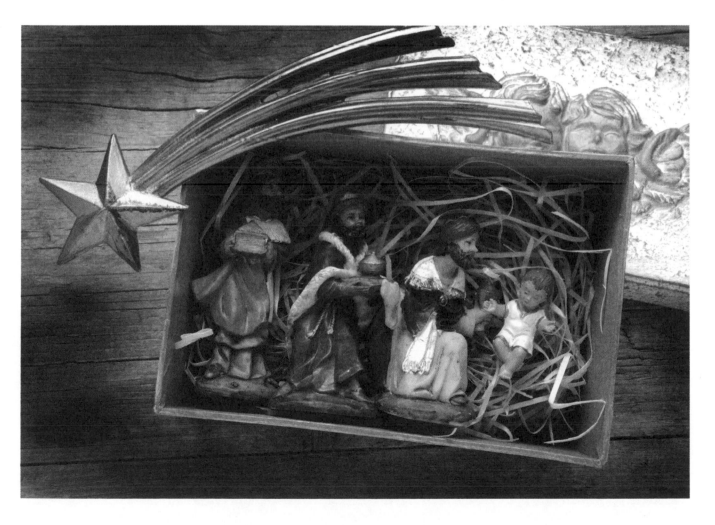

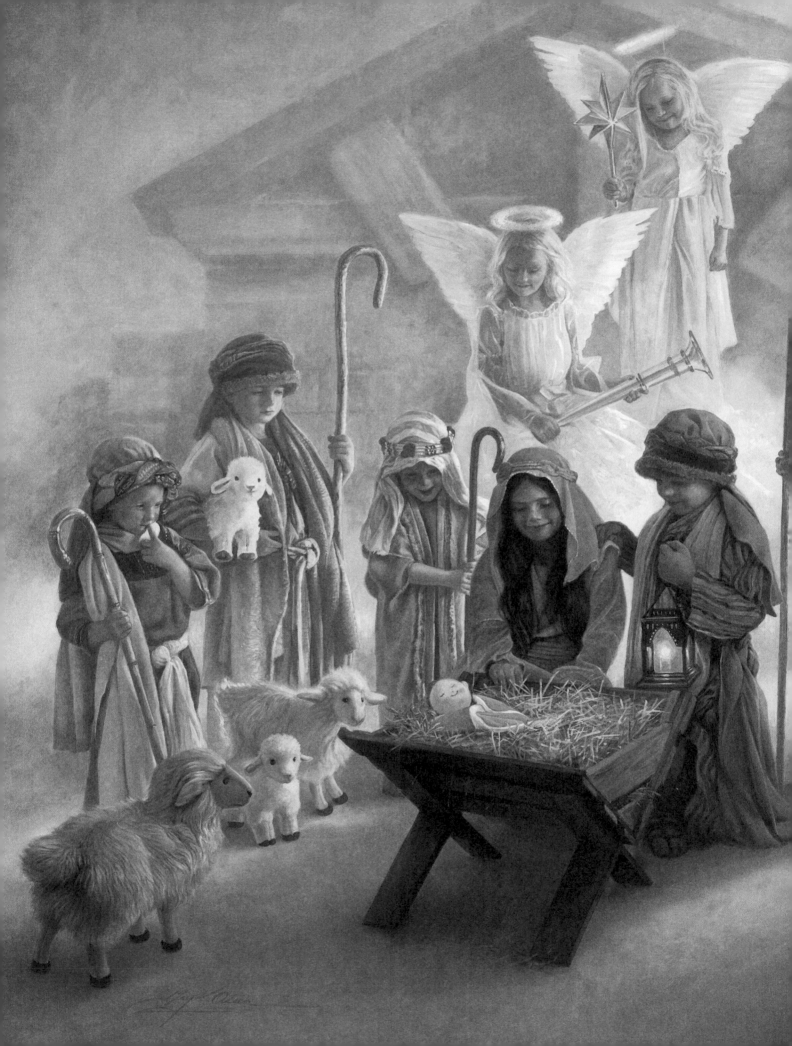

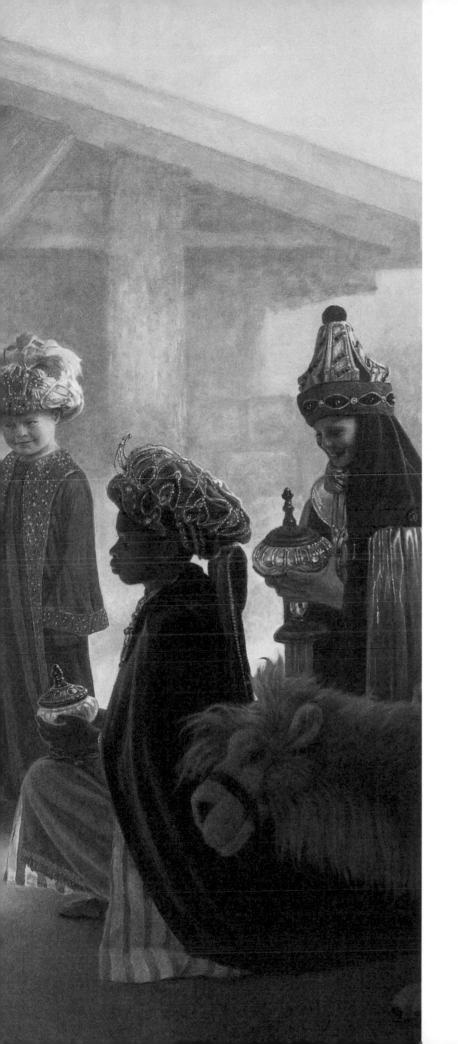

Nativity Song

Sophie Jewett

The beautiful mother is bending
low where the baby lies,
helpless and frail, for her tending;
but she knows the glorious eyes.

The mother smiles and rejoices
while the baby laughs in the hay;
she listens to heavenly voices:
"The child shall be King, one day."

O dear little Christ in the manger,
let me make merry with Thee.
O King, in my hour of danger,
wilt Thou be strong for me?

Christmas: A Gift from God

Rebecca Barlow Jordan

If all we knew of Christmas
was that a Savior came;
if we stood beside the manger,
but never knew His name;

if our hearts were never opened
by His love's warm embrace—
we'd never know that Jesus
was a gift of God's own grace.

AWAY IN A MANGER *by Greg Olsen.*
Image © Greg Olsen Art

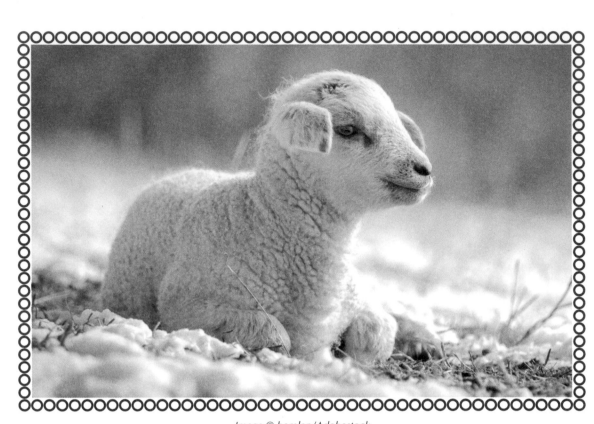

Image © hemlep/Adobestock

A Shepherd's Story

Pamela Kennedy

Tabitha's mother handed her a cloth-wrapped bundle. "Take this." Tabitha breathed in the smells of fresh bread, goat cheese, and dates.

"Thank you, *immah*." She tucked the food into her cloth bag along with her spindle stick and some loose wool.

Her mother blessed her: "Go with God, my dearest," then kissed her head and handed her the polished wooden staff that had been used by the young girls in their family for years.

When Tabitha opened the gate to the sheep pen, the fat ewes and bleating lambs pushed towards her. She laughed, calling each by name, urging them along as she headed toward the hillside above Bethlehem.

The young shepherdess plucked a few wildflowers and waved to some friends along the way. When she spread her cloak and settled on a flat rock, her sheep munched on grass or napped nearby. Taking out her spindle and wool, Tabitha twirled the wooden tool, spinning the thin yarn her mother would weave into cloth. She daydreamed as she stared at the whirling spindle. Her hours were filled with dull routines—tending sheep, spinning, minding her younger siblings. Every day felt the same. Shouldn't there be more to life?

As the sun set, Tabitha coaxed her flock into a rough pen she had created by weaving together thorny branches. She picked up the youngest lamb and snuggled him in her arms, softly singing a favorite psalm until he dozed off. As the sky darkened and the constellations appeared, Tabitha glimpsed a flash. Something brighter than a star seemed to be falling toward her. Then, in a burst of light and rushing wind, Tabitha saw a figure. She cowered, pulling her robes around her, but the brilliance and sound soon drew her to her feet. Still holding the sleeping lamb, she stared upward.

A voice rang out: "Do not be afraid. I bring you good news of great joy that will be for all the people. Today in the town of David a Savior has

thing. "Did you see?" "Did you hear?" they called out. As if led by some mystical force, they rushed through the dark village until they came to a small cave behind an inn. There they stopped, staring in wonder. It was exactly as they had been told. There, in a feeding trough, snuggled in warm hay, lay a newborn baby. The little lamb, still in Tabitha's arms, stirred. He poked out his small black nose and bleated.

"Is this the promised child?" Tabitha whispered in wonder.

"His name is Jesus," the young mother said, reaching out to touch the baby's cheek.

"Jesus," Tabitha repeated softly. And the tiny baby turned his face toward her.

A voice rang out: "Do not be afraid. I bring you good news of great joy that will be for all the people. Today in the town of David a Savior has been born to you; he is Christ, the Lord.

been born to you; he is Christ, the Lord. This will be a sign to you: You will find a baby wrapped in cloths and lying in a manger." Suddenly, hundreds, maybe thousands, of other beings filled the night sky. Tabitha heard a mighty chorus proclaim, "Glory to God in the highest and on earth peace to men on whom His favor rests." The sound tore through the air and reverberated in the heart of the young shepherdess.

Compelled by the heavenly message, she knew she had to find this baby. Still carrying the lamb, Tabitha gathered her robes around her and dashed back toward Bethlehem. As she ran, she caught sight of other shepherds doing the same

Suddenly, the young girl's heart filled with amazement and understanding. The Psalms, the promises of the prophets, the words of the patriarchs—they all pointed to this moment, to this child, heralded by angels and stars. In awe, she placed the little lamb beside the manger. "For you," she sighed. "For Him."

Later, as she ran to gather her sheep from the hillside and return home, she could hardly wait to tell her mother, her brothers and sisters, her neighbors about what she had seen. God had come to her—to all of them. He had spoken from the stars and through a tiny baby. He cared. He loved. He was *for* them. Glory to God in the highest!

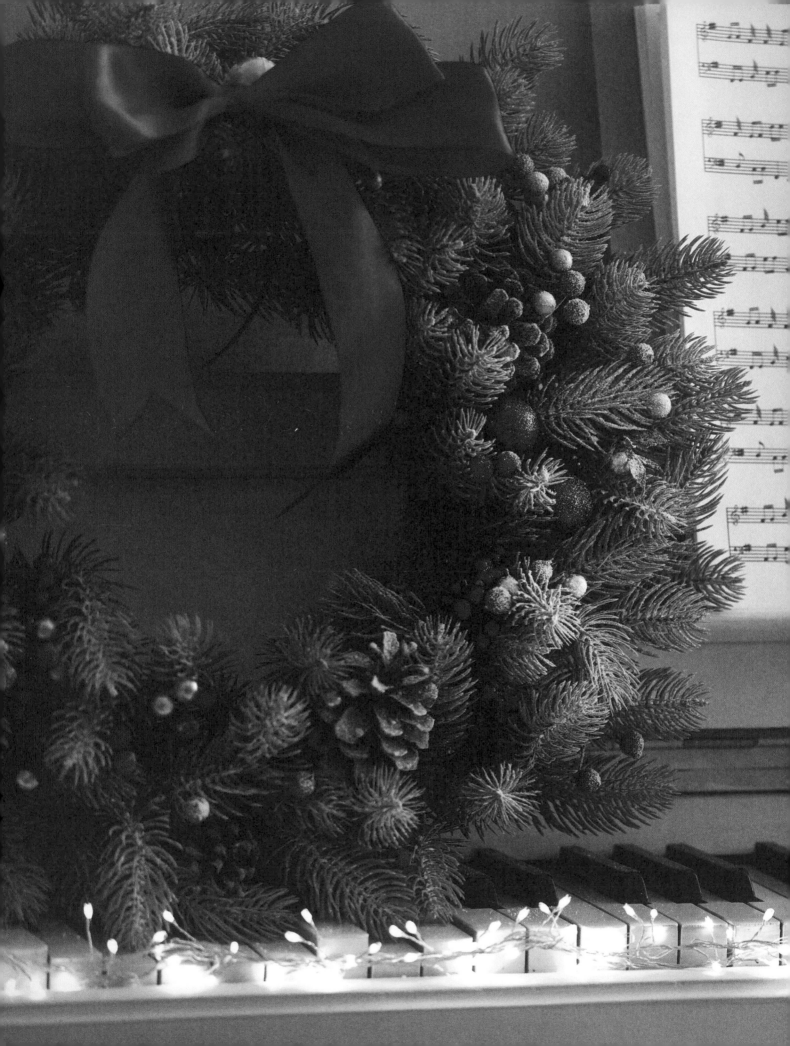

Rise Up, Shepherd, and Follow

Traditional Spiritual

There's a star in the East on
 Christmas morn—
rise up, shepherd, and follow.
It will lead to the place where the
 Christ was born—
rise up, shepherd, and follow.

If you take good heed to the
 angel's words—
rise up, shepherd, and follow.

You'll forget your flocks,
 you'll forget your herds—
rise up, shepherd, and follow.

Follow, follow, rise up,
 shepherd, and follow.
Follow the Star of Bethlehem.
Rise up, shepherd, and follow.

The Shepherds Had an Angel

Christina G. Rossetti

The shepherds had an angel,
the Wise Men had a star;
but what have I, a little child,
to guide me home from far,
where glad stars sing together,
and singing angels are?

Lord Jesus is my Guardian,
so I can nothing lack;
the lambs lie in His bosom
along life's dangerous track:
the willful lambs that go astray
He, bleeding, brings them back.

Those shepherds thro' the
 lonely night
sat watching by their sheep,
until they saw the heav'nly host

who neither tire nor sleep,
all singing "Glory, glory,"
in festival they keep.

Christ watches me,
 His little lamb,
cares for me day and night,
that I may be His own in heav'n;
so angels clad in white
shall sing their "Glory, glory,"
for my sake in the height.

Lord, bring me nearer day by day,
till I my voice unite,
and sing my "Glory, glory,"
with angels clad in white.
All Glory, glory, giv'n to Thee,
thro' all the heav'nly height.

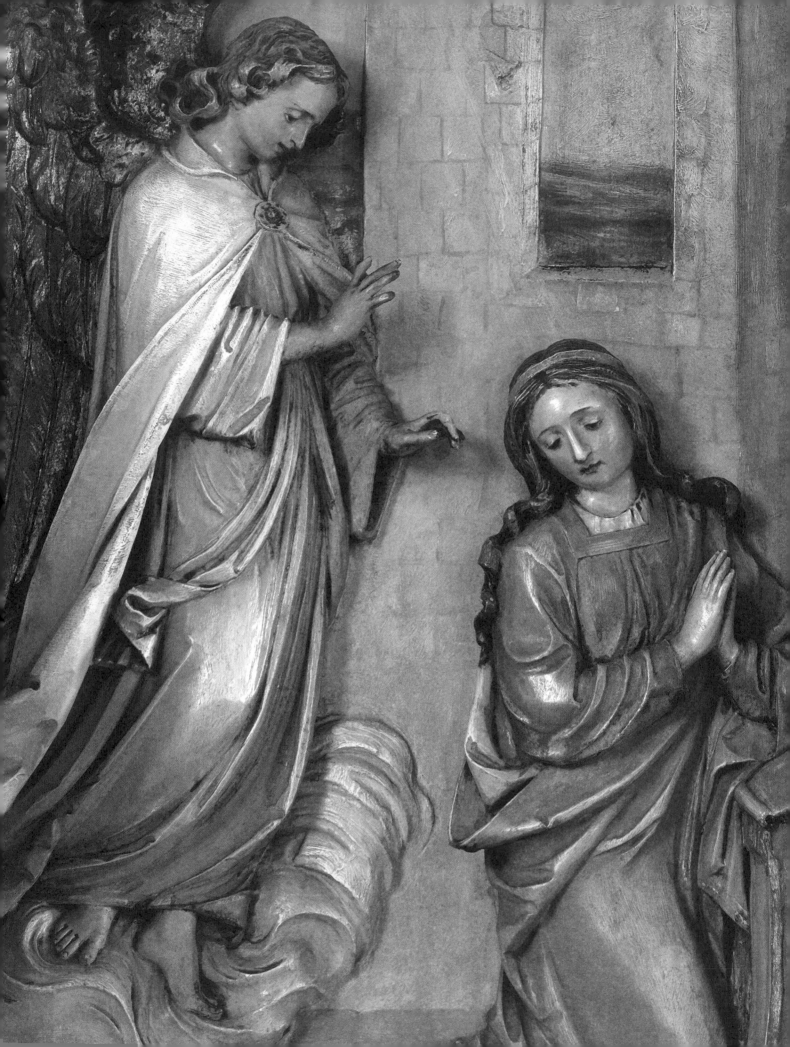

The Annunciation

Luke 1:26–33

And in the sixth month the angel Gabriel was sent from God unto a city of Galilee, named Nazareth, to a virgin espoused to a man whose name was Joseph, of the house of David; and the virgin's name was Mary.

And the angel came in unto her, and said, Hail, thou that art highly favoured, the Lord is with thee: blessed art thou among women.

And when she saw him, she was troubled at his saying, and cast in her mind what manner of salutation this should be.

And the angel said unto her, Fear not, Mary: for thou hast found favour with God.

And, behold, thou shalt conceive in thy womb, and bring forth a son, and shalt call his name Jesus.

He shall be great, and shall be called the Son of the Highest: and the Lord God shall give unto him the throne of his father David:

And he shall reign over the house of Jacob for ever; and of his kingdom there shall be no end.

Image © zatletic/Adobestock

The Nativity

Luke 2:1–7

And it came to pass in those days, that there went out a decree from Caesar Augustus that all the world should be taxed. (And this taxing was first made when Cyrenius was governor of Syria.)

And all went to be taxed, every one into his own city.

And Joseph also went up from Galilee, out of the city of Nazareth, into Judaea, unto the city of David, which is called Bethlehem; (because he was of the house and lineage of David:) to be taxed with Mary his espoused wife, being great with child.

And so it was, that, while they were there, the days were accomplished that she should be delivered.

And she brought forth her firstborn son, and wrapped him in swaddling clothes, and laid him in a manger; because there was no room for them in the inn.

Image © zatletic/Adobestock

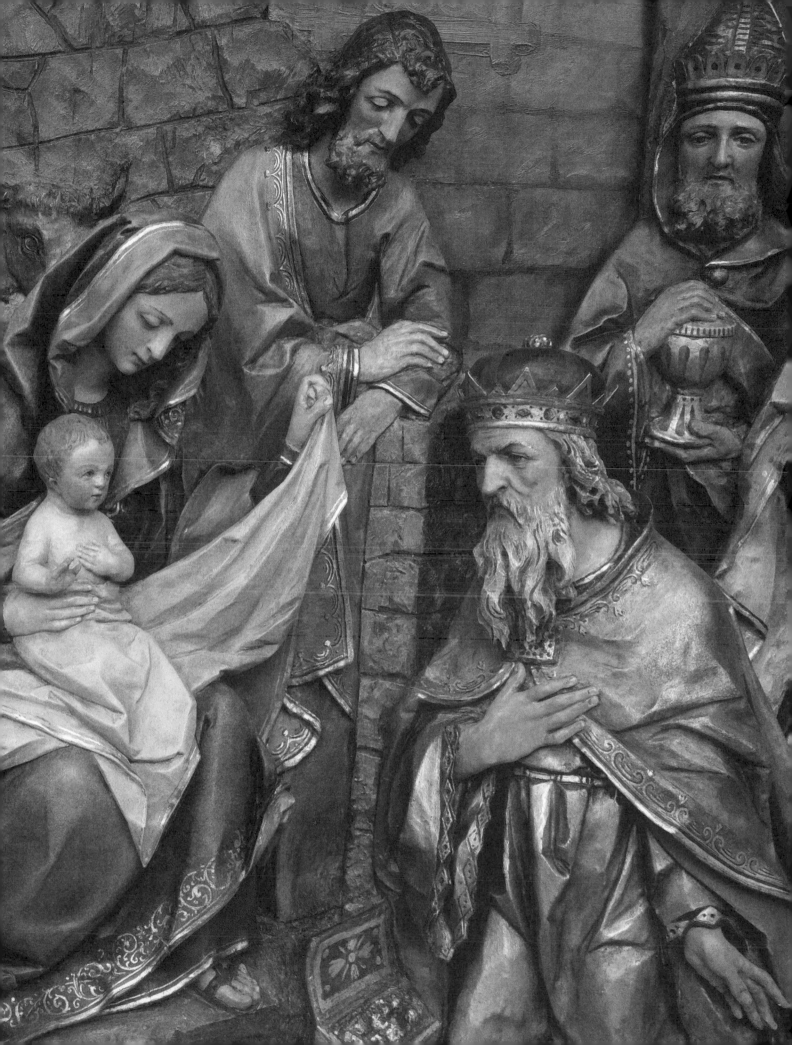

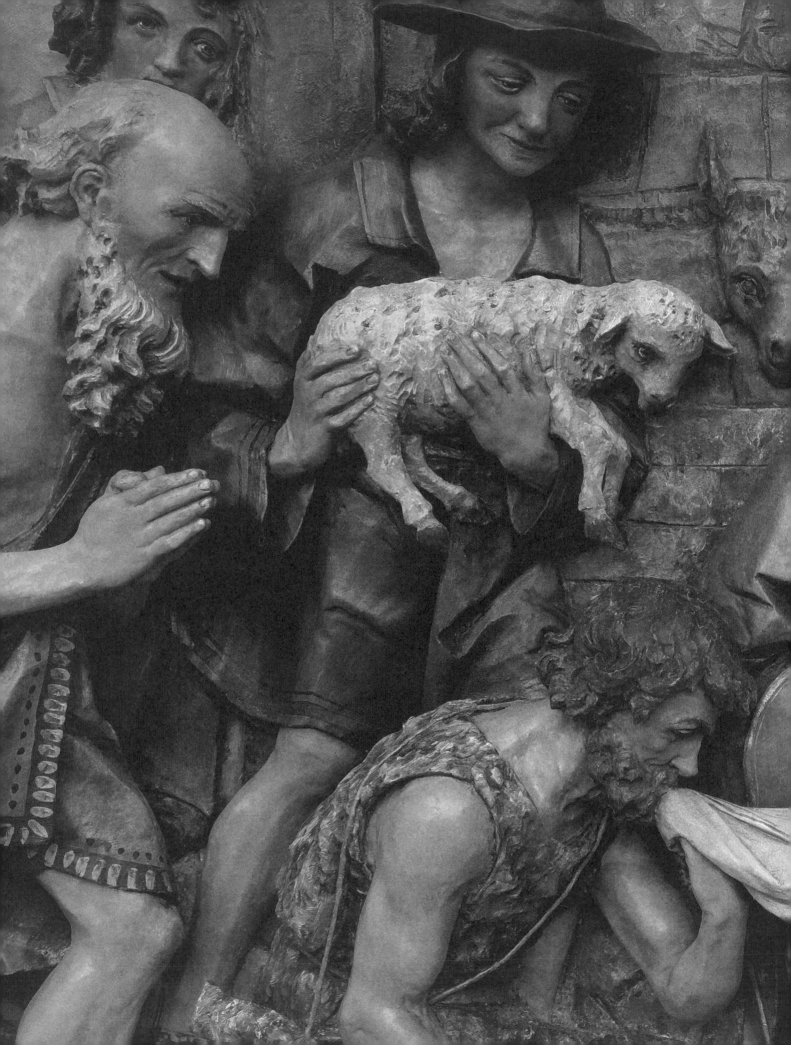

The Angels and Shepherds

Luke 2:8–14

And there were in the same country shepherds abiding in the field, keeping watch over their flock by night.

And, lo, the angel of the Lord came upon them, and the glory of the Lord shone round about them: and they were sore afraid.

And the angel said unto them, Fear not: for, behold, I bring you good tidings of great joy, which shall be to all people. For unto you is born this day in the city of David a Saviour, which is Christ the Lord. And this shall be a sign unto you; Ye shall find the babe wrapped in swaddling clothes, lying in a manger.

And suddenly there was with the angel a multitude of the heavenly host praising God, and saying,

Glory to God in the highest, and on earth peace, good will toward men.

Image © zatletic/Adobestock

Carol

William Canton

When the herds were watching
in the midnight chill,
came a spotless lambkin
from the heavenly hill.

Snow was on the mountains
and the wind was cold
when from God's own garden
dropped a rose of gold.

When 'twas bitter winter,
houseless and forlorn
in a star-lit stable,
Christ the Babe was born.

Welcome, heavenly lambkin;
welcome, golden rose;
alleluia, Baby,
in the swaddling clothes!

The Christmas Babe

Margaret Sangster

We love to think of Bethlehem,
that little mountain town,
to which, on earth's first
 Christmas Day,
our blessed Lord came down.
A lowly manger for His bed,
the cattle near in stall,
there, cradled close in
 Mary's arms,
He slept, the Lord of all.

If we had been in Bethlehem,
we too had hasted fain
to see the Babe whose little face
knew neither care nor pain.
Like any little child of ours,
He came unto His own,
through Cross and shame before
 Him stretched—
His pathway to His throne.

If we had dwelt in Bethlehem,
we would have followed fast,
and where the Star had led our feet
have knelt ere dawn was past.
Our gifts, our songs, our prayers
 had been
an offering, as He lay,
the blessed Babe of Bethlehem,
in Mary's arms that day.

Now breaks the latest
 Christmas Morn!
Again the angels sing,
and far and near the children throng,
their happy hymns to bring.
All heaven is stirred!
 All earth is glad!
for down the shining way,
the Lord who came to Bethlehem,
comes yet, on Christmas Day.

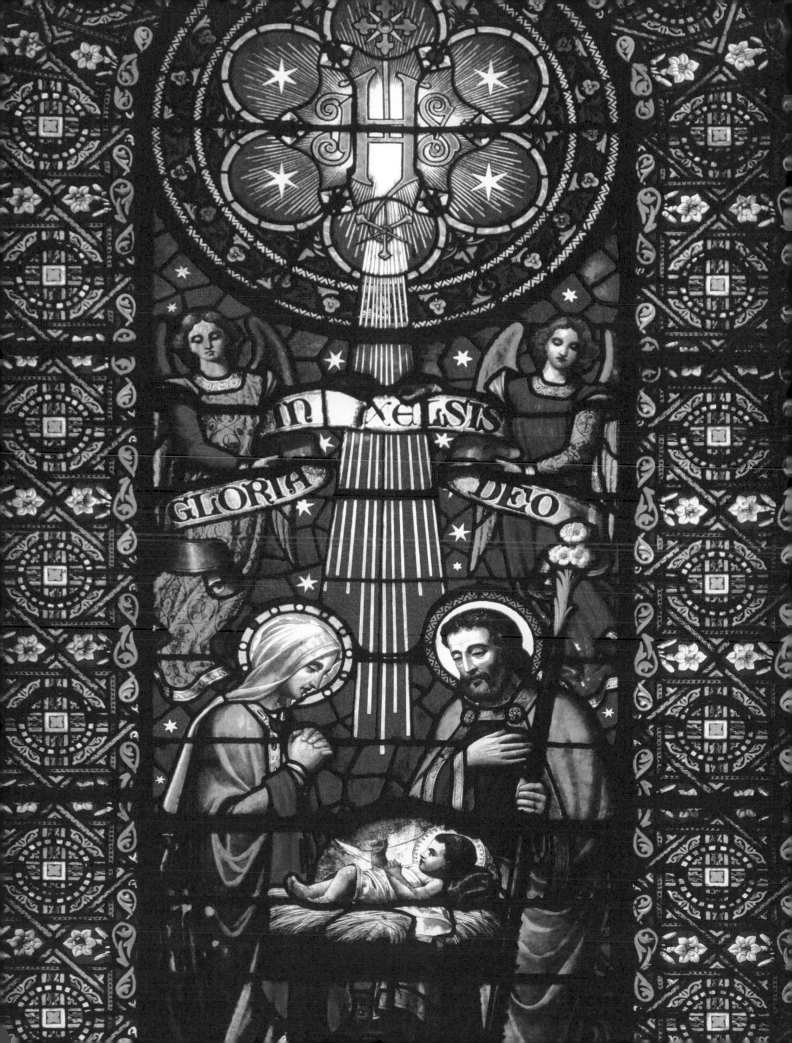

Above Them
Pamela Love

Three people in the city,
above them was a shed,
no room for them inside the inn—
a manger was Christ's bed.

Three shepherds on a hillside,
above them angels flew.
Through the angels' joyful song
they learned the blessed news.

Three Wise Men, in the distance,
above them was a star.
They headed off to see the King,
though they would travel far.

Above them all was heaven,
which sent God's love to earth.
And still, we celebrate the Christ
a present of such worth!

The Three Kings
Henry Wadsworth Longfellow

Three Kings came riding from far away,
Melchior and Gaspar and Baltasar;
Three Wise Men out of the East were they,
and they traveled by night and they slept
 by day,
for their guide was a beautiful, wonderful star.

The star was so beautiful, large and clear,
that all the other stars of the sky
became a white mist in the atmosphere;
and by this they knew that the coming
 was near
of the Prince foretold in the prophecy.

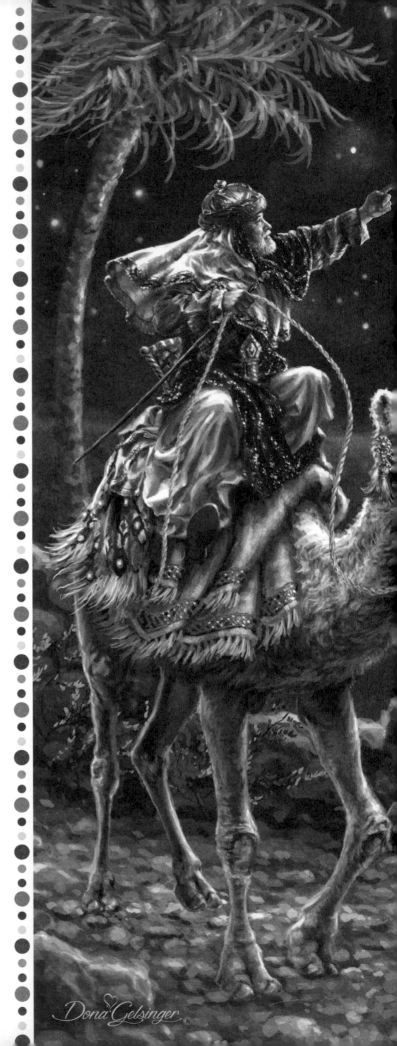

THE MAGI by Dona Gelsinger. Image ©
Gelsinger Licensing Group

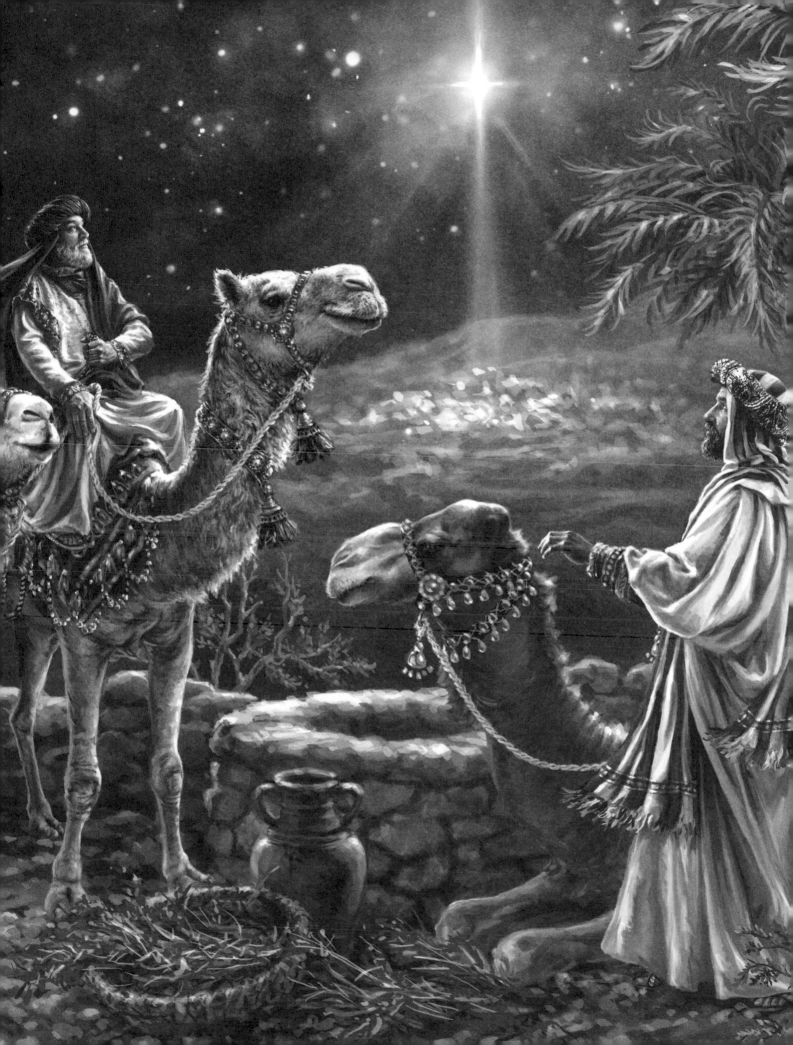

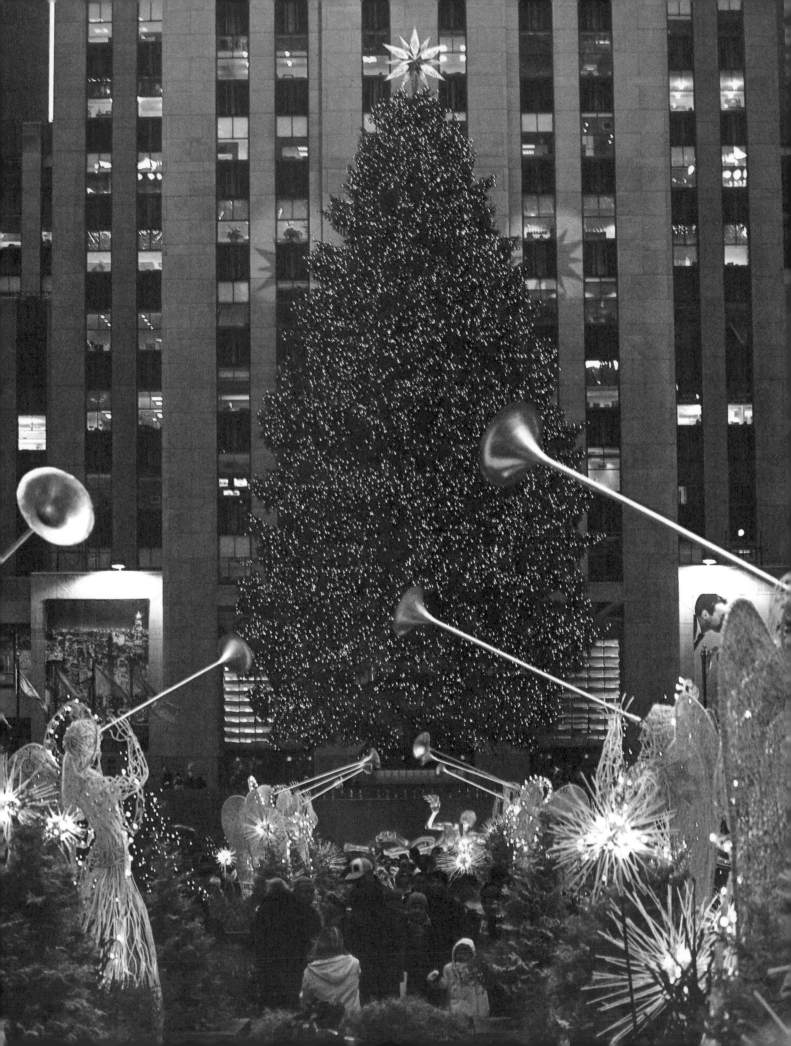

The First Noel

Traditional English Carol

1. The first No - el, the an - gel did say, was to cer - tain poor
2. They look - ed up and saw a star shin-ing in the
3. Then en - tered in those wise men three, full rev - 'rent -
4. Then let us all with one ac - cord sing prais - es

shep-herds in fields as they lay; in fields where they lay keep-ing their
east, be - yond them far, and to the earth it gave great
ly up - on their knee, and of - fered there in His pres -
to our heav'n - ly Lord, Who hath made heav'n and earth of

sheep, on a cold win - ter's night that was so deep.
light, and so it con - tin - ued both day and night.
ence their gold, and myrrh, and frank - in - cense.
naught, and with His blood man - kind hath bought.

No - el, No - el, No - el, No - el, Born is the King of Is - ra - el.

The Happy Feel of Christmas

Mamie Ozburn Odum

May the happy feel of Christmas
fill your heart to overflow
with hope and goodness
and with a Christlike glow.

Deck the halls with berried holly;
hang the mistletoe with glee;
hang the star with regal honor
high up on the Christmas tree.

May the happy feel of Christmas
clear and fill the air
as the carolers, sweetly singing,
bring joy for all to share.

May you find peace and understanding
and joy on Christmas Day,
with hope, love, and courage
to guide your daily way.

May the happy feel of Christmas
fill your sweetest thoughts and dreams
as you meet your friends and neighbors
in a Christlike love supreme.

May the happy feel of Christmas—
today and every day, my dear—
add sweetness to the season
and flow into the coming year.

DECEMBER 24TH *by Jane Wooster Scott. Image ©
Jane Wooster Scott/Porterfield's Fine Art Licensing*

A Snow Party

Faith Andrews Bedford

It is cold in the bedroom this morning. It's the kind of chill that makes you pull the covers up over your nose. As my husband and I lie in bed in that state somewhere between sleep and wakefulness, I hear the radio crackling with reports of school closings on the other side of the mountains. "Stay tuned for further announcements for counties east of the Blue Ridge," the weather forecast warns.

"The children will be so excited," I mumble sleepily to Bob. "They'll probably have a snow day." I mentally begin to plan the party we always have to celebrate the first snowfall.

"The children," Bob laughs, "don't live here anymore."

My mind snaps to attention. I realize he is right. We haven't had a snow party here for years.

The children and I always celebrated the first snowfall with a party. When they were finally tired of filling our yard with snowmen and snow angels, when they'd had their fill of endless snowball fights staged from behind the walls of their snow forts, they would troop in—cheeks rosy and noses red—and gather around the stove with big mugs of cocoa and a bowl of popcorn. For this once-a-year occasion, I would let them toast marshmallows in the woodstove—a messy affair guaranteed to mean much scraping up of gooey glops of dropped sweetness later on.

Bob comes into the kitchen. "I checked the weather channel. Looks like we're in for a big one," he says, wrapping his hands around a steaming cup of coffee. "I'd better bring in some more wood."

"Will the storm make it to the city?" I ask.

"Yup," he says. "It's going to keep moving right up the seaboard toward Boston."

I begin to smile.

"You're thinking of the girls, aren't you?" he asks.

I nod. Our daughters share an apartment in the city. Tomorrow or the next day, their desolate cityscape will be buried in a soft embrace of snow. I open a cupboard and begin rummaging around.

"What are you looking for?" Bob asks, buttering his toast. "The jam is on the table."

"I'm just looking to see if I have any popcorn," I reply. "And some cocoa."

Bob looks at me quizzically.

"If I find some, I'm going to make Eleanor and Sarah a Snow Party Kit."

Way in the back of a cupboard, I discover a half-empty jar of popcorn and a couple of cocoa packets. I grin triumphantly as I plop them down on the counter.

Bob just shakes his head and gives me an amused smile.

The house suddenly begins to make the familiar creakings it always does as it settles in for a storm. A quiet sense of expectancy envelops me as I stand at the door, watching the storm advance across the valley. The first flakes start to swirl past the windows. There is nothing quite like the first snowfall, especially when it is so late in coming and is so eagerly anticipated. If I pack up the snow party fixings and drive into the village quickly, I can get the box in this morning's mail. The girls should have it by tomorrow.

Image © Nancy Matthews/Cerise Images

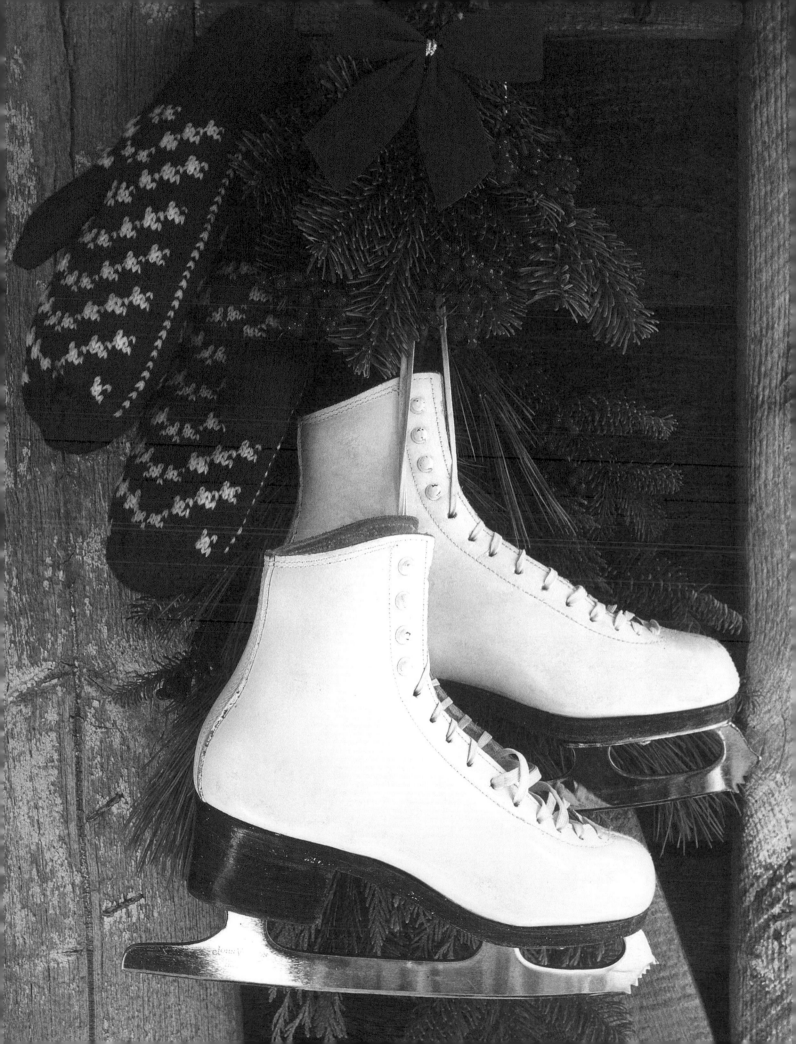

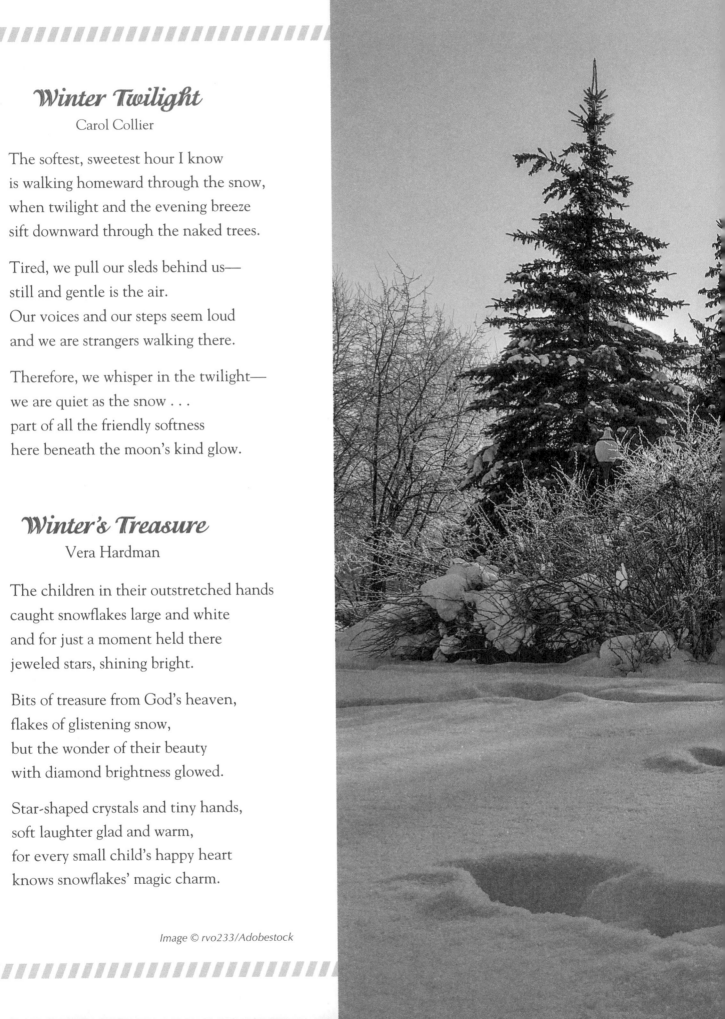

Winter Twilight
Carol Collier

The softest, sweetest hour I know
is walking homeward through the snow,
when twilight and the evening breeze
sift downward through the naked trees.

Tired, we pull our sleds behind us—
still and gentle is the air.
Our voices and our steps seem loud
and we are strangers walking there.

Therefore, we whisper in the twilight—
we are quiet as the snow . . .
part of all the friendly softness
here beneath the moon's kind glow.

Winter's Treasure
Vera Hardman

The children in their outstretched hands
caught snowflakes large and white
and for just a moment held there
jeweled stars, shining bright.

Bits of treasure from God's heaven,
flakes of glistening snow,
but the wonder of their beauty
with diamond brightness glowed.

Star-shaped crystals and tiny hands,
soft laughter glad and warm,
for every small child's happy heart
knows snowflakes' magic charm.

Snowflakes are kisses from heaven.
—Author Unknown

Making Wreaths

Joan Donaldson

I love breathing in the fragrance of evergreen branches while viewing the wreaths displayed at garden centers or where Christmas trees are sold. Some sport festive, red-plaid bows and frosted pinecones; others are simple circles of greenery waiting to be decorated with small ornaments and even tiny lights.

A couple of years ago, my husband and sons harvested grapevines from our woods and twisted them into large wreaths to give as Christmas presents. We tucked in sprays of white baby's breath flowers, creating a shimmering cloud, and adorned each one with a red ribbon bow.

One holiday season, I fell in love with a wreath formed from grasses and decorated with herbs and dried flowers. I yearned to duplicate it, not only for myself, but so I could give some as Christmas presents. So in the spring I planted rows of statice, larkspur, strawflowers, and the fragrant herb known as Sweet Annie. Throughout the summer, I plucked the blue and maroon bell-shaped statice flowers and hung their stalks along a beam in my kitchen. When the larkspur bloomed, I added pink, white, and lavender bouquets of this annual delphinium, and finally, I picked the bright strawflowers that zinged in vivid reds, golds, and hot pinks. The row of Sweet Annie plants rose to six feet and extended branches of fern-like foliage and plumes of yellow flowers. Come September, I cut the stalks and dried the plants in my garden shed. I envisioned how the flowers would adorn the wreaths—and my friends' joy when they hung up a new Christmas decoration.

One early November afternoon, my young sons and I roamed our farm gathering golden stalks of grasses, holly leaves, and tiny multiflora rose hips. About a week before Christmas, as snow fell outside our windows, I pulled out a large mixing bowl to use as a circular mold. I wrapped layers of Sweet Annie branches around it, tying the bundles with string, and the herb's pungent fragrance filled the kitchen. When the wreath was thick enough to support decorations, I wound one more length of string around it and tightened it snugly.

Working together, my sons slipped in the grasses, sprigs of rosemary, and rough-textured sage leaves while I added ruby rose hips and prickly holly leaves. Because the dried flowers were more fragile, I gently inserted their stems beneath the string, eyeing their hues to create contrast and layers of colors. Holding up each wreath, I rotated the creation to ensure it looked lovely from any angle before

we tied on a festive bow. At a Christmas party, we delivered them to our friends, and while the wreaths may not have appeared as lush as those constructed by a professional florist, they exuded a primitive, homey charm that endeared them to their recipients.

The wreaths not only contributed to the festive spirit of the Christmas holidays, but they also celebrated the four seasons. They reflected my excited expectations as seeds sprouted and flow- ered, the beauty of my summer kitchen decorated with dozens of hanging bouquets, and a garden shed perfumed by silver green foliage. The wreaths held the memory of the slanted sun on a late autumn afternoon as a mother and her children harvested from nature, anticipating the joy their labors would bring at Christmastime.

Image © MNStudio/Adobestock

Christmas Greetings
Ruth V. Hayes

With every Christmas card
 I write,
I breathe a little prayer—
that God may make your
 pathway bright
and keep you in His care.

May heavenly peace indwell
 your heart
and heavenly joys abound—
not only at this
 Christmastime,
but all the year around.

Notes of Friendship
Lela Meredith

I treasure all my
 Christmas cards;
they mean so much to me,
each one from someone
 special whom
I'd so much like to see.

Some come from friends I
 don't oft see—
they live too far away—
their cards are like a
 friendly smile
that brightens Christmas Day.

The message each one
 brings to me
from friends on my own street,

is like a gift that's
 wrapped with love,
each one a yuletide treat.

I'm thankful for these
 lovely cards
that come to me each year—
these precious notes of
 friendship with
their greetings of good cheer.

And I wish for you this
 Christmas
all the joy the season brings;
peace, good health, and
 lots of love—
the best of everything.

Image © Clive Nichols/Gap Photos

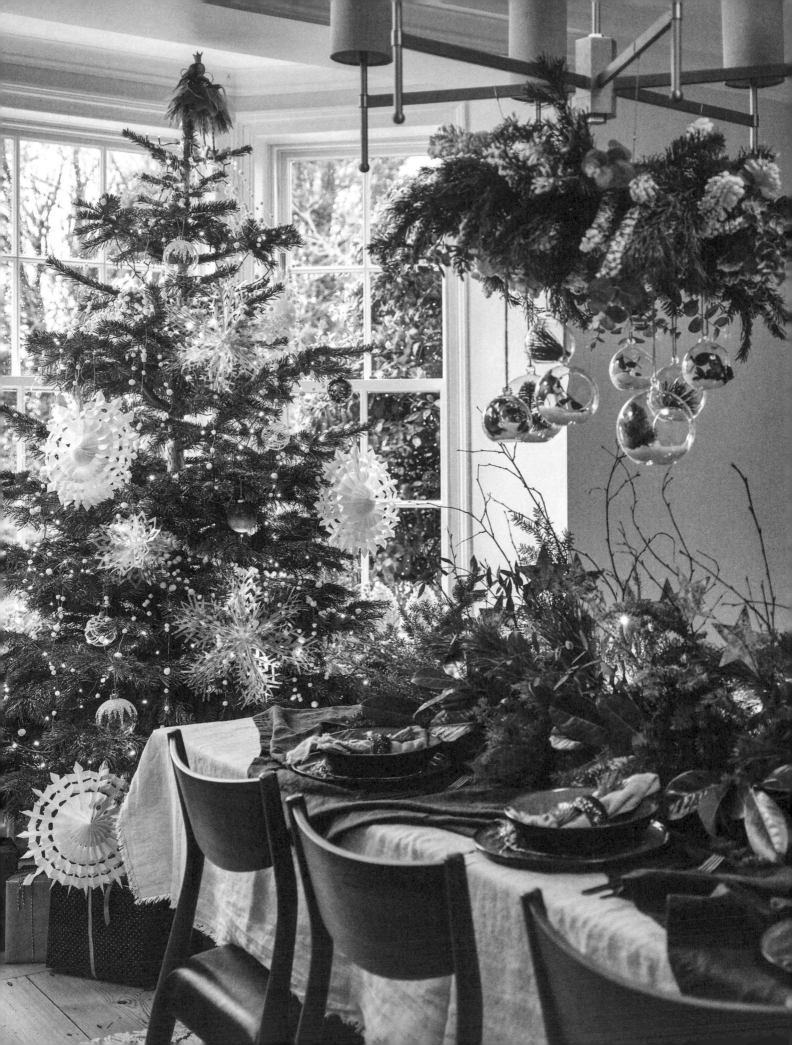

Be of Good Cheer

Jeris Hamm

The weeks before Christmas are a special time of anticipation for me. Watching holiday movies is a treasured tradition that inspires and fills me with hope.

As a young mother, I would squirrel away a little time to watch *It's a Wonderful Life*. Each time the main character, George Bailey, came oh-so-close to realizing his dreams, my heart would beat a little faster. And I'd blink away tears when events seemed to conspire against George and his dreams turned to dust.

Soon after my youngest daughter entered school, I started a new job teaching an adult education class for single women. The ladies had overcome many difficulties to attend. Some had suffered abuse and abandonment. Many had no family to help support them. Their heartbreaking experiences must have made their own dreams seem out of reach. Yet they continued to come to class and worked hard their first semester.

As Christmas drew near, the class planned a potluck dinner and a small celebration—a reward for all their hard work. I chose to show *It's a Wonderful Life*, hoping they would enjoy the story as much as I did.

In the movie, snowflakes drift softly upon the Bailey household. A real Christmas tree sparkles with simple decorations. Laughing children run through the house, familiar carols plink from the piano, and a merry Christmas celebration ensues. But the idyllic Christmas scene crumbles when George Bailey arrives home, his dreams having been dashed to despair.

The ladies cried at that part of the movie, just as I had. But as George Bailey's life was saved by the love of his friends, a new spirit of hope seemed to move through the classroom like the softly swirling snow.

One woman talked of her son and how she'd saved money to buy him a new pair of jeans for Christmas. We shared holiday plans and family recipes for sweet potatoes and cornbread dressing. Another student brought a special dessert of light pastry and honey—my first taste of baklava. We bonded, not just as students and teacher, but as friends.

The message of Christmas speaks to everyone. It is one of love and hope: of God's love for us, of our love for family and friends, and of the hope that the birth of Jesus brought to a hurting world.

Jesus has promised to deliver us from the trials and disappointments of our present lives into the joy of His presence. The happiness of Christmas reminds us of His comforting words: "Be of good cheer, I have overcome the world," (John 16:33, NKJV).

Christmas Light

Eileen Spinelli

It's the slanted light of a silver star,
the light of a tree in a shabby room.

It's lantern light from house to barn
swaying bright against the gloom.

It's the light of home across the miles.
It's the puddled light of moon-on-snow.

It's the light in eyes, in hearts, in smiles.
It's the sweetest light of all I know.

Winter Blessings

Mildred L. Jarrell

When winter winds with keenness blow
and twilight brings the falling snow,
then lighted hearth fires flare and bloom,
dispelling shadows around the room.
When family gathers for the night
to talk before the embers bright,
to join in games and lively song,
we know the warmth and love of home.
When all outdoors is wrapped in snow
and windows shine with candle glow,
we bask in blessings heaven sent
before the fire and are content.

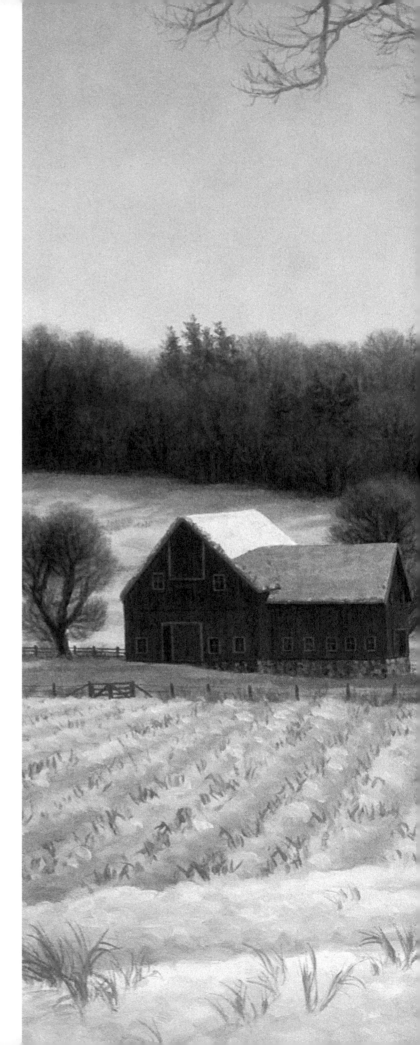

FIRST SNOW by Randy Van Beek.
Image © Randy Van Beek/Artlicensing.com